SPONTANEOUS PARTICULARS

THE TELEPATHY OF ARCHIVES

SUSAN HOWE

CHRISTINE BURGIN
NEW DIRECTIONS

Acknowledgments: Please see page 80.

Credits:
Pages 6, 42, 44, 47, 48, 49, 50, and 53: The Jonathan Edwards Papers, Beinecke Rare
Book and Manuscript Library, Yale University.
Pages 10, 12, 15, 32, 38, 40, and 41: The William Carlos Williams Collection,
1902–1960 (E28: Plans, notes and drafts for *Paterson III*, PCMS-0024), The Poetry
Collection of the University Libraries, University at Buffalo, The State University of
New York.
Pages 16 and 62: The Hart Crane Papers, Box 9, Rare Book & Manuscript Library,
Columbia University in the City of New York.
Pages 18, 24–25, 29, 57, and 58: The Emily Dickinson Collection, Amherst College
Archives and Special Collections.
Pages 19 and 23: The Antonio Ratti Textile Center, The Metropolitan Museum of Art.
Pages 20 and 36: The Charles Sanders Peirce Papers (MS Am 1632 (52) and (60)), by
permission of the Houghton Library, Harvard University.
Pages 27, 67, and 68: The Noah Webster Papers, New York Public Library Manuscripts
and Archives Division.
Pages 28: New York Public Library, Rare Book Division, Astor, Lenox and Tilden
Foundations.
Page 30: The Gertrude Stein and Alice B. Toklas Papers, Beinecke Rare Book and
Manuscript Library, Yale University.
Pages 44, 46, 59, and 60: Susan Howe's *Frolic Architecture*, The Grenfell Press, and *That
This*, New Directions, 2010.

Cover photograph by Thomas Smillie, 1890. Smithsonian Institution Archives,
Washington, DC.
Design by Leslie Miller
Manufactured in China
New Directions Books are printed on acid-free paper.
First published as a Christine Burgin & New Directions cloth book in 2014
Published simultaneously in Canada by Penguin Books Canada Limited.

Christine Burgin Books are published by
The Christine Burgin Gallery
239 West 18th Street, New York, New York 10011

New Directions Books are published for James Laughlin
by New Directions Publishing Corporation
80 Eighth Avenue, New York 10011

SPONTANEOUS PARTICULARS

THE TELEPATHY OF ARCHIVES

Oe taupaunmään,

neonook ne aunhquauch-

qeeän, noch, estaham

tunkah woork, keah

kxannowaun määnak,

ne noinny mehaiwonk-

an annennahkoan een-

hah annutahkoun. Nö-

nook nuhtamowoh Oe

taupoumean puhtem-

owoens woauhkehum eo-

tah tunkah noo poohoo-

nemmoowin.

Jonᵃ Edwards.

N.H. May 17, 1765.

Oe taupaunmeän, ~~noonook~~
noonook ne aunhquauh =
queän, nseh, estaham
tunkah wunk, keah
kⅹannouaunmeänuh,
ne notinny mehaiwank =
an annonnahkaun een =
hah annetahkaun. Noon =
nook nuhtamouweh Oe
taupaumean puhtam =
ouwuns waukhehum es =
tah tunkah noo poxken =
nummawin.

Jon.ᵃ Edwards.

N.H. *May 27, 1765.*

Spontaneous Particulars: The Telepathy of Archives was originally conceived as a lecture, and the images I projected in my slide-show presentation were taken from various research libraries and special collections.

They come from the Emily Dickinson Collection at Amherst College, the William Carlos Williams Collection at SUNY Buffalo's Poetry Collection, the Hart Crane papers at Columbia University, the Charles Sanders Peirce papers at Harvard's Houghton Library, the Ratti Textile Center at the Metropolitan Museum of Art, the Noah Webster papers at The New York Public Library, the Jonathan Edwards Collection and the Gertrude Stein and Alice B. Toklas papers at Yale University's Beinecke Library, and my book *Frolic Architecture*, printed as a limited edition at The Grenfell Press.

As they evolve, electronic technologies are radically transforming the way we read, write, and remember. The nature of archival research is in flux; we need to see and touch objects and documents; now we often merely view the same material on a computer screen—digitally, virtually, etc. While I realize that these technologies offer new and often thrilling possibilities for artists and scholars, *Spontaneous Particulars: The Telepathy of Archives* is a collaged swan song to the old ways.

I'll begin with the marvelous opening of Book III, *The Library*, from William Carlos Williams' *Paterson*:

9

The Literary

To drown the roar, ~~stopped at the~~ library
for peace, searching the old town for relief
the provincial quiet for a clue to the
resolution of that turmoil - Snow falling,
the lights on a Christmas eve for peace.
A meaning, a meaning ? What did they know
and feel we do not know ? The falls silenced,
~~ice posturing grotesquely,~~ burnt out -
stillness ? Gesturing — *ingrown*

I love the locust tree
the sweet white locust
 How much?
 How much?
How much does it cost
to love the locust tree
 in bloom?

A fortune bigger than
Avery could muster
 So much
 So much
the shelving green
 locust
whose bright small leaves
 in June
lean among flowers
sweet and white at
 heavy cost

 A cool of books
will sometimes lead the mind to libraries
of a hot afternoon, if books can be found
cool to the sense to lead the mind away.

Now you pause, motionless, the arm

down. #####################

 Beautiful thing

(inviting reflection -)

(and) a memory ############################

of gentleness

the chance magnificence of breast

neck and shoulder

 Beautiful Thing

and the forgotten face, (most of all)

hiddne now and brooding -

######upon that lily stem. The incredible

nose, ######## straight from

the ###### brow -

That rides the mind in immaculate

 conflicts

the empurpled lips and eyes of some
 wild
 ########## thing

that makes a########### temple of

its place of savage slaughter

 consummately beautiful

 thing -

and the looseness of will that still

drives men to violence (& women too)

under the triumph and nameless brilliance

of that velvet skin - and to rest

 Beautiful thing

For there is a wind or ghost of a wind
in all books echoing the life
there, a high wind that fills the tubes
of the ear until we think we hear a wind,
actual .

 to lead the mind away.

Drawn from the streets we break off
our mind's seclusion and are taken up by
the books' winds, seeking, seeking
down the wind
until we are unaware which is the wind and
which the wind's power over us .

 to lead the mind away

and there grows in the mind
a scent, it may be, of locust blossoms
whose perfume is itself a wind moving
 to lead the mind away

through which, below the cataract
soon to be dry
the river whirls and eddys
 first recollected.

Spent from wandering the useless
streets these months, faces folded against
him like clover at nightfall, something
has brought him back to his own
 mind .

 in which a falls unseen
tumbles and rights itself
and refalls—and does not cease, falling
and refalling with a roar, a reverberation
not of the falls but of its rumor
 unabated

 Beautiful thing,
my dove, unable and all who are windblown,
touched by the fire
 and unable,
a roar that (soundless) drowns the sense
with its reiteration
 unwilling to lie in its bed
and sleep and sleep, sleep
 in its dark bed.

Searching among books; the mind elsewhere
looking down .

 Seeking.

The

of casions,

~~The cassions'~~ grinding whirr, ~~the~~ torrid sledge,

realignment

~~Her~~ axle ~~conformations~~, arctic gongs,

~~alignment~~ ~~natal~~

Meridian ~~displacements~~ in the throes

girdles

~~Season measures of~~ thy thighs, O bridge; *Axis*

Dreadful, the blossoms of ~~the~~ *this* faith unfold;

From riven stems into an unrecked sky

Kiss of our agony thou gatherest.

Make our love sure, to lift whose song we die!

eclipses

ellipses

To be, Great Bridge, in vision bound of thee,

So widely chartered, straight and ocean-wound,

River-harbored, irridescently upborne

Through the bright drench and fabric of our veins.--

With white escarpments swinging into light,

Sustained in tears the cities are endowed

And justified conclamant with the fields

Revolving through their harvests in sweet torment.

Serenities, anathema to say,

O Bridge, synoptic foliate dome!

Always through blinding cables to our joy

--Of thy release, the square prime ecstasy.

Through the twined cable strands, upward

Veering with light, the flight of strings,

Kinetic choiring of white wings . . ascends.

In *The H.D. Book* (a collection that until 2011 only existed in separate chapters in out-of-print little magazines, and hard to locate web sites), Robert Duncan writes: "The secret of the poetic art lies in the keeping of time, to keep time designing or discovering lines of melodic coherence. Counting the measures, marking them off, calculating the sequences; the whole intensified in the poet's sense of its limitation … one image may recall another, finding depth in the resounding." Duncan also speaks of "the Romantic spirit and back of that the Spirit of Romance … under boycott." He wrote this in 1961. The taboo is even more severe now. But I believe, this currently exiled spirit (Keats' "Beauty is truth, truth beauty—," Stevens' "The giant body the meanings of its folds, / The weaving and the crinkling and the vex," WCW's "beautiful Thing:/ —a dark flame," and "beauty is / a defiance of authority"), this visionary spirit, a deposit from a future yet to come, is gathered and guarded in the domain of research libraries and special collections.

—

On June 20, 1926, Hart Crane, then staying on his mother's family property on the Isle of Pines, Cuba, while working on what he hoped would be his epic poem *The Bridge*, wrote to Waldo Frank: "The form of my poem rises out of a past that so overwhelms the present with its worth and vision that I'm at a loss to explain my delusion that there exist any real links between that past and a future destiny worthy of it. The 'destiny' is long since completed, perhaps the little last section of my poem is a hangover echo of it—but it hangs suspended somewhere in ether like an Absalom by his hair."

Possibly during 1885, the year before she died, Emily Dickinson wrote in a letter to her sister-in-law Susan,

"Emerging from an Abyss, and re-entering it that is Life, is it not, Dear?

"The tie between us is very fine, but a Hair never dissolves."

Things-in-themselves and things-as-they-are-for-us.

Often by chance, via out-of-the-way card catalogues, or through previous web surfing, a particular "deep" text, or a simple object (bobbin, sampler, scrap of lace) reveals itself *here* at the surface of the visible, by mystic documentary telepathy. Quickly—precariously—coming as it does from an opposite direction.

If you are lucky, you may experience a moment *before*.

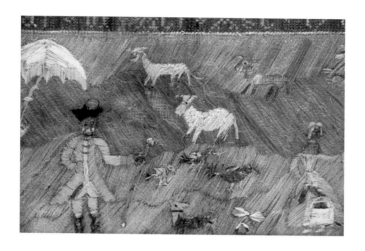

The English word "text" comes from Medieval Latin *textus* "style or texture of a work," literally "thing woven," from the past participle stem of *textere*: "to weave, to join, fit together, construct." In several notebooks she labeled "Sentences" (1928–1929), Gertrude Stein writes: "A sentence is partly softly after they write it. What is the difference between a sentence and a sewn. What is the difference between a sentence and a picture. They will sew which will make it tapestry. A sentence is not carrying it away. A sentence furnishes while they will draw. A sentence is drawers and drawers full of drawings. A sentence is an imagined masterpiece. A sentence is an imagined frontispiece. In looking up from her embroidery she looks at me. She lifts up the tapestry. It is partly. . . . Think in stitches. Think in settlements. Think in willows."

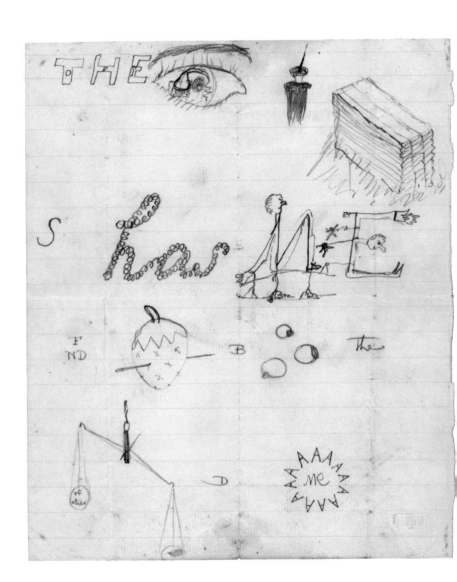

An article by Edward Moore and Arthur Burks on editing the manuscripts of the philosopher Charles Sanders Peirce has an epigraph taken from the horse's mouth: "I am a mere table of contents ... a very snarl of twine."

—

In research libraries and collections, we may capture the portrait of history in so-called insignificant visual and verbal textualities and textiles. In material details. In twill fabrics, bead-work pieces, pricked patterns, four-ringed knots, tiny spangles, sharp-toothed stencil wheels; in quotations, thought-fragments, rhymes, syllables, anagrams, graphemes, endangered phonemes, in soils and cross-outs.

In 1907 Henry James placed his second novel *Roderick Hudson* first in the twenty-four volume Scribner's New York collection of his novels, novellas, and short stories. Near the beginning of the "Preface" he wrote for this edition he asks: "Where, for the complete expression of one's subject, does a particular relation stop—giving way to some other not concerned in that expression? Really, universally, relations stop nowhere, and the exquisite problem of the artist is eternally but to draw, by a geometry of his own, the circle within which they shall happily *appear* to do so. . . . All of which will perhaps pass but for a supersubtle way of pointing the plain moral that a young embroiderer of the canvas of life soon began to work in terror, fairly, of the vast expanse of that surface, of the boundless number of its distinct perforations for the needle, and of the tendency inherent in his many-coloured flowers and figures to cover and consume as many as possible of the little holes. The development of the flower, of the figure, involved thus an immense counting of holes and a careful selection among them. That would have been, it seemed to him, a brave enough process, were it not the very nature of the holes so to invite, to solicit, to persuade, to practise positively a thousand lures and deceits."

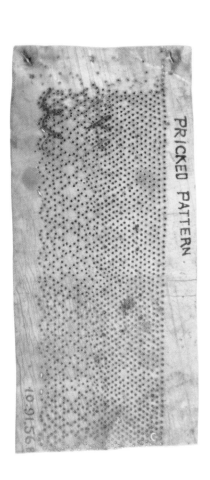

PRICKED PATTERN

One historical-existential trace has been hunted, captured, guarded, and preserved in aversion to waste by an avid collector, then shut carefully away, outside an economy of use, inaccessible to touch. Now it is re-animated, re-collected (recollected) through an encounter with the mind of a curious reader, a researcher, an antiquarian, a bibliomaniac, a sub sub librarian, a poet.

Each collected object or manuscript is a pre-articulate empty theater where a thought may surprise itself at the instant of seeing. Where a thought may hear itself see.

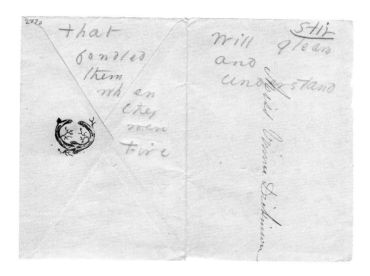

For conversion, there must be a mysterious leap of love. Sometimes, a hidden verso side acts as prior counterpoint. The way improvised children's tales have needlepoint roots in Latin holy words and medieval jargon. What difference does it make if what we see before our mind's eye has already been interpreted? This meanly magnificent "waste" exists on a scale beyond actual use. It provides us with a literal and mythical sense of life hereafter—

Coming home to poetry—you permit yourself liberties—in the first place—happiness.

—

On August 19, 1926, Hart Crane ended a letter to Waldo Frank this way: "I have never been able to live completely in my work before. Now it is to learn a great deal. To handle the beautiful skeins of this myth of America—to realize suddenly, as I seem to, how much of the past is living under only slightly altered forms, even in machinery and such-like, is extremely exciting. So I am having the time of my life just now, anyway."

Webster's dictionary has defined skein this way: "Skain, *n*. [Fr. *escaigne*] A knot or number of knots of thread, silk, or yarn. A loosely coiled length of yarn or thread, wound in a reel suitable for a manufactoring process (as dying) or for sale as knitting wool or embroidery.

"Something suggesting the twistings and contradictions of a skein ('unraveled the tangled skein of evidence'). A trimmed strip of osier made from splits for basketwork. A metal thimble on an axletree arm.

"A flock of wild fowl in flight."

—

Words are skeins—meteors, mimetic spirit-sparks. Noah Webster's 1828 *Dictionary* is repeatedly invoked by our 19th-century North American intepreters, Emerson, Melville, Hawthorne, Dickinson, Whitman, and many others. Often the Calvinist lexographer's terse definitions, particularly when read aloud, resemble prose poems.

4

Adorable. See under adore

Adore. v.t. L. adoro from Ch & Heb. הדר to honor, reverence, to adorn. The radical sense appears to be to adorn, or decorate make splendid; from דר to encompass; for this הדר דר to go round are allied in sense; & from this root is formed חרוזים rows of jewels for ornament, whence Eng. tire, attire. See attire, crown, ornament. whose radical sense is round, a circle. Hence the Ch. הדר signifies not only to honor, but to return, & דוּרים things twisted. This root hadar, has a like sense in the Syriac; & also signifies a little ring, the year.

Edward Dickinson's copy of the first 1828 edition was in the family library and Emily Dickinson herself owned an 1844 reprint of the 1841 edition. Noah Webster was one of the founders of Amherst College along with her grandfather Samuel Fowler Dickinson, and her father was on the board of The Amherst Academy, the co-educational primary school she attended and where, for a time, Webster served as President pro tem of the school board. In 1862 she told Thomas Wentworth Higginson: "When a little Girl, I had a friend, who taught me Immortality—but venturing too near, himself—he never returned—Soon after, my Tutor died—and for several years my Lexicon—was my only companion—"

Noah Webster: "STITCH, *v. t*: 1. To sew with a back puncture of the needle; so as to double the thread; as, to *stitch* a wristband; To sew or unite together; as, to *stitch* the leaves of a book and form a pamphlet.

"2. To form land into ridges. *New England*.

"*To stitch up*, to mend or unite with a needle and thread; as to *stitch up* a rent; to stitch up an artery."

AVIA

Running over affinities and relations, as was her practice, Dickinson could discover on the previous STI page of her Lexicon Companion the definition for STICH pronounced STICH. "(Stick) n. 1. In *poetry*, a verse of whatever measure or number of feet. [*Stich* is used in numbering the books of Scripture.]

"2. In *rural affairs*, an order or rank of trees.

"[In New England, as much land as lies between double furrows, is called a *stich*, or a land.]" Or, she could skip down to the next word: "STICH-O-MAN-CY, Divination of lines or passages of books taken at *hazard*."

After Dickinson's death, this note was found among her papers. "What a Hazard an Accent is! When I think of the Hearts it has scuttled or sunk, I almost fear to lift my Hand to so much as a punctuation."

———

Quotations are skeins or collected knots. "KNOT, (*n.*, *not* ...) The complication of threads made by knitting; a tie, union of cords by interweaving; as, a *knot* difficult to be untied." Quotations are lines or passages taken at hazard from piled up cultural treasures. A quotation, cut, or closely teased out as if with a needle, can interrupt the continuous flow of a poem, a tapestry, a picture, an essay; or a piece of writing like this one. "STITCH, *n.* A single pass of a needle in sewing."

"If they look alike and are not sisters. All at once. Dove and dove-tail."

the language
pouring down
 beautiful thing
the language, the
 language
to dull ears —
 harsh —

or why write?

"The search is a poet for his language—to collate with the language of the noise of the Falls, which seems in itself to be a language which we were, and are still seeking—."

Between 1946 and 1958, William Carlos Williams labored over *Paterson,* a work he conceived as "a long poem in four parts" (he eventually completed five, and at the end of his life had started on a sixth). The five were published by New Directions in separate limited editions—my favorite, Book III, *The Library,* in 1949. He later said that in *Paterson* he wanted to use the "multiple facets which a city presented as representatives for comparable facets of contemporary thought thus to be able to objectify the man himself as we know him and love him and hate him. This seemed to me to be what a poem was for, to speak for us in a language we can understand. . . . Thus the city I wanted as my object had to be one that I knew in its most intimate details. . . . I deliberately selected Paterson as my reality." Once he had fixed on the city he needed to gather and collect facts in relation to the place, especially to the Passaic River and its Falls, from libraries, local and otherwise. The first sentence of the preface to *Paterson*: "Rigor of beauty is the quest."

Wallace Stevens began his Preface to Williams' *Collected Poems, 1921–1931*: "There are so many things to say about him. The first is that he is a romantic poet. This will horrify him. Yet the proof is everywhere." (And the preface did annoy Williams—to say the least.) Fifteen years later in *Rubbings of Reality*, an essay published in the *Briarcliff Quarterly*, Stevens tells us: "Williams is a writer to whom writing is the grinding of a glass, the polishing of a lens by means of which he hopes to be able to see clearly. His delineations are trials. They are rubbings of reality. . . .The German pietists of the early 1700s who came to Pennsylvania to live in the caves of the Wissahickon and to dwell in solitude and meditation were proceeding, in their way, from the chromatic to the clear. Is not Williams in a sense a literary pietist, chastening himself, incessantly, along the Passaic?"

In Book III, a Romantic literary Pietist enters the library in the hope of unraveling tangled skeins of evidence. Paterson (he has named himself for his city) rifles through old newspapers and local histories with their genteel accounts of celebrations, picnics, suicides—.

Spontaneous sound particulars balance the scale of law with magic.

 Sit breathless
or still breathless. So be it. Then, eased
turn to the task. So be it :
 Old newspaper files,
to find—a child burned in a field,
no language. Tried, aflame, to crawl under
a fence to go home. So be it. Two others,
boy and girl, clasped in each other's arms
(clasped also by the water). So be it. Drowned
wordless in the canal. So be it. The Paterson
Cricket Club, 1896. A woman lobbyist. So
be it. Two local millionaires—moved away.
So be it. Another Indian rock shelter
found—a bone awl. So be it. The
old Rogers Locomotive Works. So be it.
Shields us from loneliness. So be it. The mind
reels, starts back amazed from the reading .
So be it.

How is this
for blue ?

How is this ?
for blue ?

How is this ?
for blue ?

Blue, unmistakably
it is but rather
dingy blue
un

Reading *Paterson* reminds me of walking barefoot across a small strip of common land near my house that's littered with beach glass, broken oyster shells, razor clams and kelp. It's called a beach, but no one swims there because even at high tide what is euphemistically referred to as "sand" quickly becomes marl, mud, and marsh grass. I feel the past vividly here—my own memories and the deeper past I like to explore in poems. As I look across Long Island Sound I can imagine it as open ocean.

 O Thalassa, Thalassa!
 the lash and hiss of water

 The sea!

 How near it was to them!

 Soon!

 Too soon .

Guilford is almost a suburb. The other day driving home from
New Haven listening to NPR on the car radio, I heard suburbs
described as places successful people flee from now, so increas-
ingly only the poor and the old are left. At the end of Book III the
"wadded" library, once Paterson's hoped for sanctuary, is muffled
and dead. It disappoints. Are libraries suburbs?

> —whatever the complexion. Let
> me out! (Well, go!) this rhetoric
> is real!

Phone: RUtherford 2-0669 Reg. No. 3810
WILLIAM C. WILLIAMS, M.D.
9 Ridge Road Rutherford, N. J.
Office Hours: 1 to 2 P.M. Except Friday
Evenings 7 to 8 P.M., Monday and Thursday

Name _____ Age ____
Address _____ Date ____

For many years I taught and lived in Buffalo, another hard-up provincial northeastern or easternmost midwestern rust-belt city with a crueler Niagara river and its larger, more dramatic Falls. But it wasn't until last September when I returned to give a reading that I took time to look at (and touch) some of the many typed and re-typed drafts, notes scribbled on prescription forms, stories cut from newspapers and pamphlets that Dr. Williams used as fuel for the fire of poetic artifice.

<div align="center">

Whirling flames, leaping
from house to house, building to building

carried by the wind

</div>

The Library is in their path

Beautiful thing! aflame .

<div align="right">

a defiance of authority

</div>

—burnt Sappho's poems, burned
by intention (or are they still hid
in the Vatican crypts?) :

<div align="center">

beauty is

</div>

a defiance of authority :

<div align="center">

for they were

</div>

unwrapped, fragment by fragment, from
outer mummy cases of papier mâché, inside
Egyptian sarcophagi .

Niagara Falls and the Great Falls of the Passaic River. Names are supposed to be signs for *things*, but what if *things* are actually the signs of *names*? What if *words* possess a "spirit" potential to their nature as *words*? Then things of experience in their passage between languages might materialize into posthumous vowel notes whipped up with shifting consonantal impact until by a side-step or little jump, the embroidered manifestation of an earlier vernacular reflects authority (edenic justice) through ciphered wilderness and pang.

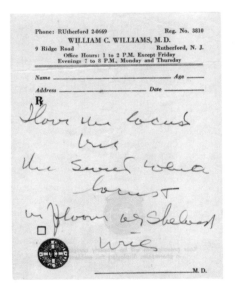

Prescription. Prefatory writing, order, rule—the establishment of a claim of title to something under common law by virtue of immemorial use. A recipe. A written direction for the preparation, compounding, and administration of a medicine.

Name. Age. Address. Date.

—

When we were children playing games of hide-and-seek the person chosen to be "it" now turned round, alone and counting—was supposed to keep looking, in spite of snares and false resemblances.

Ask the librarian behind the desk for a cardboard box of labeled file folders containing singular whispering skeletons.

Place one in my looking-glass hands.

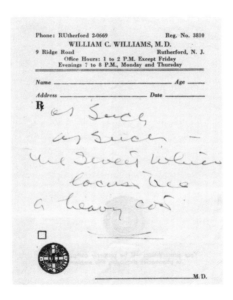

This consecrated branch transmits to posterity the benefits of seeds or buds hidden in trees for thousands of years.

Faith

"Faith!" shouted Goodman Brown, in a voice of agony and desperation; and the echoes of the forest mocked him, crying, 'Faith! Faith!' as if bewildered wretches were seeking her, all through the wilderness."

Nathaniel Hawthorne: "Young Goodman Brown" (1835).

—

Previous work I have done in terms of manuscripts and archives led me to the massive collection of the papers of the 18th-century New England theologian—some say our first American philosopher—Jonathan Edwards, in New Haven at Yale's Beinecke Rare Book and Manuscript Library, one of the largest buildings in the world devoted entirely to rare books and manuscripts. The Beinecke was constructed from Vermont marble and granite, bronze and glass, during the early 1960s. The structure displays and contains acquisitive violence, the rapacious "fetching" involved in collecting, and, on the other hand, it radiates a sense of peace. Downstairs, in the Modernist reading room I hear the purr of the air filtration system, the rippling sound of pages turning, singular out of tune melodies of computers re-booting. Scholars are seated at wide worktables bent in devotion over some particular material object. They could be copying out a manuscript or deciphering a pattern. Here is deep memory's lure, and sheltering. In this room I experience enduring relations and connections between what was and what is.

I remember the summer before my sister Jerusha's death,

... making ...

and I was leaning over the south fence and thinking in this
manner, that I was never likely to do better and where should I
go etc.

The Beinecke's vast collection of Edwards family memorabilia contains letters, diaries, notebooks, essays, and more than twelve hundred sermons (most of them in miniscule script). Jonathan Edwards was the only son among ten unusually tall sisters their minister father jokingly referred to as his "sixty feet of daughters." Their mother, Esther Stoddard Edwards, also known for her height, taught her eleven children and others in their Northampton farmhouse. Later they received the same education their father provided to local boys in his parish in East Windsor, Connecticut. The girls were tutored along with their brother (and in some cases they tutored him) in theology, philosophy, Latin, Greek, Hebrew, history, grammar and mathematics. They attended finishing school in Boston. But almost all that remains from this 18th-century family's impressive tradition of female learning are a bedsheet probably woven by Jonathan's mother, a tiny blue fragment of his wife Sarah Pierrepont Edwards' wedding dress, a journal kept by Esther Edwards Burr (their oldest daughter) and several raggedy scraps from his younger sister Hannah's private writings—

The folio-size double leaves that Jonathan, Sarah, and his ten tall sisters wrote on were often homemade: hand-stitched from linen rags salvaged from worn out clothing or sometimes on scraps left over from dress patterns. Lists, sermons, quotations of psalms, dissonant scripture clusters, are pressed between coarse cardboard covers with frayed edges. The rag paper color has grown deeper and richer in some.

all the organs consisting of little threads, or nerves: by the wa
as frequently happiness
some parenthesis which darkens the sense

Harmony continues to exist through fact and experience—
though there is no reason why it should—nor is there any proof
you can read back to the notion of one mind's inner relation with
nature's vibratory hum. Lyric poets can't move heaven and earth in
order to say things, language separates from music through yearn-
ing muted rhythmic pulse—through stepwise voice motion—

Haughtiness is always little violence

Three of Edwards' manuscript books I particularly love are
titled *Efficacious Grace*. Two of them he constructed from dis-
carded semi-circular pieces of silk paper his wife and daughters
used for making fans. If you open these small oval volumes and
just *look*—without trying to decipher the minister's spidery script,
pen strokes begin to resemble textile thread-text. Surface and
meaning co-operate to keep alive in one process mastery in service,
service in mastery.

(v)

~~Infidel Charity~~

fficacious Grace

7, 8, 9, 18, 11. 44, 45, 46, 47, 48, 49, 50 in part,
70 in part, prof ... 51, 52, 53, 54, 56, * the
54, 55, ... 56, 57, 58, 59

Luke 10. 21, 22.
Joh. 6. 37.
v. 44.
v. 45.
v. 65.
mat. 16. 17.

... hath ...
... it unto the ...
... by bade my ...

[John] 8. 34. "whosoever
... hath sin, or the servant
...". v. 36. "if the son
... make you free, ye shall
be free indeed".
... 47. "He that is of God heareth
... word. ye therefore hear
... not, because ye are not of
...".

... 15. The Parable of the
Shepherd's going to seek they ...
... the field, & bringing it home ...
... the Pool coin, & of the ...
... her lost piece of silver; ...
... application ... in these ...
... joy in Heaven over one ...
... there ... with the ...

... 29, 25, 26. And
... I say unto you, it is easier
... a camel to go through the ...
... of a needle ... who
... can be saved? But Jesus beh...
... them & said unto them,
... men this is impossible:
... with God all things are possible".
... 10. 25, 26, 27. Luke
... 25, 26, 27. "other sheep I have
John 10. 16 ...
... not of this fold: them also ...
... bring; & there shall be one ...
... flock, & ... shepherd". v. 26. 27. "...
... ye believe me not, because ...
... not of my sheep; as I ...
... unto you. My sheep hear my ...
... know them, &
... follow me: & I
... unto them eternal
... they shall ... with
... perish, we ...
...

Efficacious
grace

Sheer verbal artistry can be a force for mercy. I have always been drawn to Edwards, even his fire-eating sermons where each judging word has its own particular cell. Especially the notorious "Sinners in the Hands of an Angry God: A Sermon Preached at Enfield, July 8th, 1741, at a Time of Great Awakenings" with its chilling epigraph from Deuternomy 32, "Their Foot shall slide in due time," because he understands the way in which single words and sentence clusters directly effect involuntary memory. Involuntary memory is lucid, pre-verbal, soothing.

Hit or miss—an arrow into the eye of loving.

One day, by chance, I opened a folder titled: *Wetmore, Hannah Edwards, Diary: in the hand of her daughter Lucy Wetmore Whittlesey*. Inside was a copy of "the private writings" of Jonathan's sister. Lucy's late 18th-century italic script (easier to read than her uncle's or her mother's earlier handwriting) begins in media res with an excerpt from Psalm 55.6.

"Oh that I had wings like a dove! *for then* would I fly away, and be at rest."

The visual and acoustic shock of that first exclamatory "Oh" on paper brown with oxidation, made me think in a rush of Henry James' great novel *The Wings of the Dove* (1902) and the beauty of the King James version of Psalm 55 in relation to its wide use in this novel where James so perfectly finds his form for the work that follows after. The fictional orphaned American heiress Milly Theale, "stricken and doomed, condemned to die under short respite, while also enamoured of the world," is based on James' American cousin Minny (Mary) Temple, whose early death from tuberculosis in March 1870 (she was twenty-four, he was twenty-six) he feeds on as an artist.

Oh! that I had the wings of a dove, that I might
fly away and be at Rest — but whether could I
fly, Oh that I could find some more sure & abiding
~~good~~ portion, and no longer be the sport, of these
alluring, deceiving, enjoyments. I am weary with per=
suing Shaddows, where shall I find Real & Substantial
good — How long shall I wander from Mountain to
Hill seeking Rest and finding none. Oh, that
~~I could~~ find the way ~~but I cannot~~ could but find a
rest for ~~the sole~~ of my foot. but I am Lost and
bewildered, and weary myself to find the way,
but cannot — I am weary with my vain Life
yet afraid to Die. —

I am plagued all my Life long with a Levity of
mind, which flutters & tosses me, to & fro, from one
vanity to another; till I am weary, & Heart sick, in
persuing Shadows, & things, that I know, are nothing
— But when I am deeply afflicted, by some great
Dissapointment, or the loss of something dear unto me,
it Poises my mind, & a little tames my Frenzy.

In 1914, at the end of his long writing career, James closed the second volume of his memoirs *Notes of a Son and Brother* (William died in 1910) with a chapter built around extracts from letters Minny had written to their mutual friend, John Chipman Gray, by then a distinguished professor at the Harvard Law School and the author of two influential treatises, "Restraints on the Alienation of Property" (1883) and "The Rule against Perpetuities" (1886).

Gray's side of the correspondence with Minny has been lost, but he saved hers until shortly before his own death when, anxious they would be lost, he brought them to William's widow. She suggested they be sent to Henry, who was gathering material for *Notes*. Before sending Minny's correspondence across the ocean, Alice and her daughter Mary Margaret carefully transcribed the originals in longhand. At some point these copies were deposited in four folders at Houghton Library where Alfred Habegger discovered them during the 1980s.

Chapter XIII of *Notes* ends with this paragraph: "Death, at the last, was dreadful to her; she would have given anything to live—and the image of this, which was long to remain with me, appeared so of the essence of tragedy that I was in the far-off aftertime to seek to lay the ghost by wrapping it, a particular occasion aiding, in the beauty and dignity of art. . . . Much as this cherished companion's presence among us had represented for William and myself —and it is on *his* behalf I especially speak—her death made a mark that must stand here for a too waiting conclusion. We felt it together as the end of our youth."

Psalm 68: "The wings of a dove covered with silver, its pinions of fine gold."

James heavily doctored the originals Gray had provided. (According to Habegger "there was scarcely a sentence he did not emend.") Then he destroyed them. He also left out the extraordinary letters she sent both to himself and to William—the brother he said he was speaking for.

M. Temple—present as absent—the imaginary friend known to be imaginary but impossible to let go. Her initials play their part as reflectors in *The Wings of the Dove*. Five years later in "The Question of our Speech," an address to the graduating class at Bryn Mawr College, Henry James told the assembled audience: "All our employment of constituted sounds, syllables, sentences, comes back to the way we say a thing, and it is very largely by saying, all the while, that we live and play our parts." Then how do I pronounce the last name of his fictive "figure in the gilded coach as it comes forth"?

A teal is a small wild fresh-water fowl. Its flesh is food for hunters. But James has seeded the word with the spectral grapheme *h* and the plant, "wrapped in the dignity of art," has grown so that when I read T h e a l e on the page and say it aloud to myself, this aspirate puff of breath co-implicates his fictional birdwoman with wealth, theatricality and death.

"Where youth grows pale, and spectre-thin, and dies"—T h e a l e reflects the orthography of John Keats' "Ode to a Nightingale" where frequent digraphs *ea* and *th* flourish as letter-spirits. "I have been half in love with easeful Death, / Call'd him soft names in many a musèd rhyme, / To take into the air my quiet breath."

When I read Minny Temple's letters so artfully arranged to form the climax of *Notes of a Son and Brother*, the last letters of the orphan poet—also "stricken and doomed, condemned to die under short respite"— serve as images or shadows.

"Up from the mystic play of shadows," Walt Whitman, walking along Long Island's north shore at Paumanok, listens to a migratory sea-bird pouring forth meanings in measureless measures.

"Whereto answering, the sea,
Delaying not, hurrying not
Whisper'd me through the night, and very plainly
 before daybreak,
Lisp'd to me the low and delicious word death,
And again death, death, death, death"

Theale leads to the limit of breath. The grapheme *h*, breath's last letter remnant, hangs suspended somewhere in ether like an Absalom by his hair.

320

One note from
One Bird
Is better than
a million word —
a scabbard
has — holds
but — one
sword

Alice James' copy of the last letter Minny wrote to Gray on February 16, 1870—she died on March 8th—ends this way: "I feel the greatest longing for summer, or spring. I think I would like it to be always spring for the rest of my life, & and to have all the people I care for always with me, & never speak of going away—but who wouldn't like it so? Good-bye—write soon. I hope you are successful with your lectures. I should like to hear you give them. Are respectable spinsters allowed?

"Always affectly yrs,

"Mary Temple"

In 1905, two years after finishing *The Wings of the Dove*, James returned to America after a twenty year absence. Recalling his visit in *The American Scene* (1906) in a section titled "Cambridge and Harvard," he described catching sight of Gray: "I went into the new Law Library, immense and supreme—in the shadow of which I caught myself sniffling the very dust, pre-historic but still pungent, of the old. I saw in the distance a distinguished friend, all alone, belatedly working there, but to go to him I should have had to cross the bridge that spans the gulf of time, and, with a suspicion of weak places, I was nervous about its bearing me."

Wisdom of Solomon V.11. "Or as when a bird hath flown through the air, there is no token of her way to be found, but the light air being beaten with the stroke of her wings and parted with the violent noise and motion of them, is passed through, and therein afterwards no sign where she went is to be found."

had the wings of a dove tha
, but whether could , I fly,Oh
: & abiding PORTION and no
ring, deceiving, enjoyment
s, where shall I find Real ;
I wander from mountain
ne---Oh that I could fin'
rest for the sole of m
' --d weary myself t

In research libraries and special collections words and objects come into their own and have their place again. This known world. This exact moment—a little afterwards—not quite—

Most of my writing life has been spent in Connecticut not far from where Hannah Edwards Wetmore lived and wrote. Reading her "private writings" I experience, through an occult invocation of verbal links and forces, the qualities peculiar to our seasonal changing light and color. It's a second kind of knowledge—tender, tangled, violent, august, and infinitely various.

walking just below my father's orchard (after I ha
walking just below my father's orchard (after I ha
religion and the concerns of my soul my busine
prayed for an labored after an awakening sense 6

Early November evening with frost forecast—the sight of a
bare bough caught by streetlight outside my window—electric.
False beauty and confined beauty. Relict.
 The closer I look—the farther away your interlaced co-conscious
pattern.

 Names shelter us under the wings of first creation. Hannah's
first name begins and ends with the aspirate phoneme *h*. Spectral
letter *h*—occult—quick thought—reached through the fire of art—
 To reach is to touch.

Not wings alone, but rhythm of wings

Not wings alone, but rhythmsof spread wings

Not wings alone, but the spread wings' rhythm
Is freedom's issue and the ~~braizsfx~~ pulse of light

peripheries of light — doom an
unyielding
 falcon —
 that's
A ~~drone~~ *made* *legible to lifted eye*
The prophecy now risen from its script
Is it but a lifting of the arm, a throb of wrist
that ~~thisx~~ these shall be—these circling wings *sustained*
strum of aetherial motors ~~ridingxsunward~~
 sunward riding? *Through cloud scarf*
~~th~~ *Through cloud-scurf*
~~faintly~~ they lapse into the blue, twigs of steel
O where ~~musxx~~ all those answers, Masters
of speeding light, so quick they overtook
the words you spoke, ~~cutting~~ clean *the sky's dim rafters*
the last perpheries of light where ocean touches land
and ~~where you sang of the lost bird, O Walt!~~
 There sings the lost bird, Walt!

To trail its immanence in every

in spiral
~~the very~~ *sentences proven in the skies*

The dream of Dladelus, registered

The zone of ~~angel~~ *angels — doom shelters in cloud rings*

The cipher — decipherings — winged Sesame
The clipped
⊙ Steadinose as a star, a razor sheen
the .

, the ,
as you air co.
g moon ren .
yh hang poised it,
rifmt air, nor had
rl at he far reaches
 oth land and
ew at id, or swim e
nild , flu of things o
 odds

Poetry has no proof nor plan nor evidence by decree or in any other way. From somewhere in the twilight realm of sound a spirit of belief flares up at the point where meaning stops and the unreality of what seems most real floods over us. The inward ardor I feel while working in research libraries is intuitive. It's a sense of self-identification and trust, or the granting of grace in an ordinary room, in a secular time.

1699 Trans plant

Trans. plant. a.' tion

 planting in anot

Trans. plant.' er n̲

Tran. splen. dent ɡ

*Trans.' pōrt. n̲ ecsta
 for transportatiɡ*

*Trans. pōrt v̲b to car
 pleasure, to vi*

Trans. pōrt. a.' ble

Trans. pōrt. a' tiɡ

Trans. pōrt. er V̲

1699 Trans·plant.
Trans·plant. a'tion
 planting in anot
Trans·plant! er *n*
Trans·plan·dent
Trans·port. *n*. exsta
 for transportati
Trans·port *ot* to *u*
& pleasure, to *w*
 Trans·port a ble
Trans·port -a'tio
Trans·port· er *b*

the quality of being

may be transmitted

of sending from one

sending through

transmitted, sent, deliver

one to another, to pass

mission

may be transmitted

susceptibility of

tance.

le of change into

1698

A the quality of being

d may be transmitted

l of sending from one
sending through
ansmitted, sent, devised

m one to another, to pass

mission

may be transmitted

susceptibility of
nstance.

ble of change into

la th ʺ tʿ

ENDNOTES

PAGE 6

Jonathan Edwards, Jr. (1745–1801), prayer in Mahican, 1765.

"Oh my Lord, these things that you do for me are what you never again have to protect me from by taking away sin whether I am doing it or thinking about it. Now help me, oh my Lord God, so that I will not ever be in darkness. -Jona[than] Edwards, N[ew] H[aven], May 27, 1765" (translation by Carl Masthay).

Jonathan Edwards' son Jonathan Jr. spoke and wrote in Mahican. Some small samples still survive (diary entries and this dedicatory prayer) and he later published a treatise (1788) on the resemblance of Mahican and other native dialects to Hebrew, as support for the "Lost Tribes" theory.

PAGE 7

Susan Howe (with Kenneth Minkema), transcription of prayer in Mahican.

PAGES 10, 12, 15

William Carlos Williams (1883–1963), typescripts for *Paterson* Book III, *The Library*, 1946–1949.

PAGE 16

Hart Crane (1899–1932), manuscript fragment from "Atlantis" section of *The Bridge*, c. 1925.

PAGE 18

Emily Dickinson (1830–1886), manuscript fragment A 752, late 1885. This line is also in Letter 1024, to Susan Gilbert Dickinson.

Emerging from
an Abyss and
entering it again –
That is Life, is
it not?

PAGE 19
Rebekah White (1753–1823), detail of embroidered silk on linen sampler, North Salem, Massachusetts, 1766; Accession Number: 1984.331.8.

PAGE 20: Charles Sanders Peirce (1839–1914), manuscript number 60 from "Caricatures, Doodles, Drawings, Pen Trials," n.d.

PAGE 23
Pricked pattern for lace, British, 19th century; Accession Number: 10.91.56b.

PAGES 24, 25
Emily Dickinson, front and back of manuscript A 277, penciled poem draft inscribed on parts of both sides of a slit-open envelope addressed by Abigail Cooper to "Miss Vinnie Dickinson," c. 1876.

Long Years
 stir
apart – can who says That Will gleam
make no the Absence fondled and
Breach a of a them understand
second cannot witch when
fill – In – validates they
+The absence his spell ? were
 a
of the witch The embers Fire
 cannot
does not of a
Invalidate Thousand
a
the spell - years

 years

+ uncovered

 by the Hand

Dim - Far -

72

PAGE 27
Noah Webster (1758–1843), draft of etymology of words "Adonis" through "Adore," before 1806.

PAGE 28
Samuel Johnson (1709–1784), *A Dictionary of the English Language: in which words are deduced from their originals, and illustrated in their different significations by examples from the best writers. To which are prefixed a history of the language, and an English grammar,* from the library of and with undated annotations by Noah Webster, definition of words beginning with the letters SIZ–SKE, 1755.

PAGE 29
Emily Dickinson, manuscript A 21, pencil draft on a piece of stationary, c. 1872.

A Word dropped
careless on a Page
May stimulate an
Eye consecrate
When folded in
perpetual seam
The Wrinkled Maker
lie Author

Infection in the
sentence breeds
 may
~~And~~ we inhale
Despair
At distances of
Centuries
From the Malaria –

PAGE 30
Gertrude Stein (1874–1946), cover of her *carnet* "Sentences" with Stein's handwriting, 1928–29. The Stein quotes on page 19 and the "Dove and dovetail" passage on page 31 are taken from three different "Sentences" *carnets*.

PAGE 32
William Carlos Williams, manuscript for *Paterson*, Book III, *The Library*, 1946–1949.
"the language / pouring down / beautiful thing / the language. The / language / to dull ears— / how see— / or why write?"

PAGE 36
Charles Sanders Peirce, pen trial number 52 from "Caricatures, Doodles, Drawings, Pen Trials," n.d.

PAGE 38
William Carlos Williams, draft of *Paterson*, Book III, *The Library*, on prescription pad, 1946–1949.
"Near a waterfall / How much / How much / How much does / it cost / to love the"

PAGE 40
William Carlos Williams, draft of *Paterson*, Book III, *The Library*, on prescription pad, 1946–1949.
"I love the locust / tree / the sweet white / locust / in flower as shelved [?] / writes"

PAGE 41
William Carlos Williams, draft of *Paterson*, Book III, *The Library*, on prescription pad, 1946–1949.
"as such / as such / the sweet white / locust tree / a heavy cost [?]"

PAGE 42
Jonathan Edwards (1703–1758), *Miscellaneous Observations Concerning Faith* notebook, n.d.

Hannah Edwards Wetmore (1713–1773), diary fragment, c. 1738.

"I remember the summer before my sister Jerusha's death, about
nine years ago (I was all that summer in a great hurry, and mak-
ing stays was then my business): I was one evening walking just
below my father's orchard (after I had taken up many resolutions
to make religion and the concerns of my soul my business, and
after I had often set myself to it, and prayed for and labored after
an awakening sense of my miserable condition: and finding I yet
remained very insensible, I thought with a great deal of concern
about growing so old in sin, and remaining so insensible and
negligent, notwithstanding so many means and resolutions[)];
and as I was leaning over the south fence and thinking after this
manner, that I was never more likely to be sensible than now,
what should I do next, where should I go, etc., instantly, without
one chain of thought, I saw a Bible open before me (or at least I
had as lively and sensible an image of it on my mind as if I had
seen it with [my] eyes[)]. Which a little surprised me, but I at-
tempted to read, but did as sensibly seem to be hindered by a
piece of stays intercepting and covering the pages. This repre-
sentation was exceeding lively and sensible, and did not seem to
be lead into my mind by anything, but as it were thrown in
abruptly and so strong that it made me cast in my mind whether
I had not some reason to look upon it as supernatural. But I con-
sidered I was very unable to judge of the power of imagination,
and that there was many operations in my mind to me as unac-
countable as this, though not so now. So I left myself."

Hannah Edwards Wetmore's younger sister Jerusha Edwards died of diph-
theria on December 22, 1729.

Susan Howe, *Frolic Architecture*, The Grenfell Press, 2010, and *That This*,
New Directions, 2010.

PAGE 46
Susan Howe, *Frolic Architecture*, The Grenfell Press, 2010, and *That This*, New Directions, 2010.

PAGES 47–50
Jonathan Edwards, *Efficacious Grace* notebook 3, n.d.
One of three notebooks made from various scraps of paper used for making fans and bound by hand.

PAGE 53
Hannah Edwards Wetmore, "Private Writings" transcribed by her daughter, Lucy Wetmore Whittelsay, after her mother's death, n.d.

"O! that I had the wings of a dove, that I might fly away and be at rest— But whither could I fly, O, that I could find some more sure & abiding good portion, and no longer be the sport, of these alluring, deceiving, enjoyments. I am weary with pursuing shaddows, where shall I find real & substantial good— How long shall I wander from Mountain to Hill, seeking Rest and finding none— Oh, that I could find the way but I cannot. could but find a rest for the sole of my foot. but I am lost and bewildered, and weary myself to find the way, but cannot— I am weary with my vain Life yet afraid to Die—

"I am plagued all my Life long with a levity of mind, which flutters & tosses me to & fro, from one vanity to another; till I am weary, & heart sick, and pursuing shaddows & things that I know, are nothing.

"— But when I am deeply afflicted, by some great Disappointment, or the loss of something dear unto me, it poises my mind, & a little tames my frenzy."

PAGE 57
Emily Dickinson, manuscript A 320, penciled text fragment inscribed on torn-away flap of an envelope, c. 1880s.

Dim – Far –

Long Years
apart – can
make no
Breach a
second canno
fill –
+The absence

PAGE 58
Emily Dickinson, manuscript A 169, penciled text fragment on white stationery, c. 1880s. This trace fragment is a variant wording of the line "For he is grasped of God" in the poem beginning "Drowning is not so pitiful."

Grasped by
God –

PAGE 59
Susan Howe, *Frolic Architecture*, The Grenfell Press, 2010, and *That This*, New Directions, 2010.

PAGE 60
Susan Howe, *Frolic Architecture*, The Grenfell Press, 2010, and *That This*, New Directions, 2010.

PAGE 61
Hart Crane, work sheet for "Cape Hatteras" section of *The Bridge,* c. 1925.

peripheries of light - doom etc -
 myrmidons
 that's falcon -
A drone leads legible to lifted eyes
The prophecy now rises from its script

 these circling wings sustained
 ~~ridings sunward~~
 Through cloud scurf
 Through cloud-scurf
~~faintly~~
 float

 The sky's dim rafters
 There singing the lost bird, Walt!
To trail its imminence in song
in spiral
~~the only~~ sentences proved in the skies

The dream of Daedelus, registered

The zone of ~~nih~~ myth - doom shelters in cloud drift

The cipher - decipherings - winged Sesames.
The clipped
O stanchioned as a star, a razor sheen
The ʾ

78

—

"Having gone so high as we could with the bote, we met divers Salvages in Canowes, well loaden with the flesh of Beares, Deere, and other beasts, whereof we had part, here we found mighty Rocks, growing in some places above the grownd as high as the shrubby trees, and divers other solid quarries of divers tinctures; and divers places where the waters had falne from the high mountaines they had left a tinctured spangled skurfe, that made many bare places seeme as guilded. Digging the growne above in the highest clifts of rocks, we saw it was claie sand so mingled with the yeallow spangles as if it had beene halfe pin-dust."

Captain John Smith,
The Generall Historie of Virginia, New England & the Summer Isles (1624)

ACKNOWLEDGMENTS

For help on all transcriptions and general information on Jonathan Edwards and Hannah Edwards Wetmore, I owe my thanks to Kenneth Minkema, Executive Editor of *The Works of Jonathan Edwards* and of the Jonathan Edwards Center and Online Archive at Yale University. Here I am interested in the visual effect of the handwriting and paper surface of images from the notebook titled *Efficacious Grace*. A fully annotated transcription can be found in *The Works of Jonathan Edwards*, Executive Editor, Kenneth P. Minkema, and *Writings on the Trinity, Grace, and Faith*, edited by Sang Hyun Lee: both from Yale University Press, 2002. And a transcription of the page from "Miscellanies" on page 58 can be found in *The Miscellanies: a-500 (The Works of Jonathan Edwards Series*, Volume 13), edited by Thomas A. Schafer. I owe Nancy Kuhl, a fellow poet and the Beinecke's Curator of Poetry, Yale Collection of American Literature, thanks for her invaluable assistance over the years with any number of my researches, including the Gertrude Stein papers and the Edwards material reproduced here. I thank Marta Werner for her transcriptions of Emily Dickinson's poems and manuscripts reproduced here. I owe Jen Bervin a debt of gratitude for having first shown me the wonders contained in the Antonio Ratti Textile Center at the Met, as well as for some of the photographs we took during our visits. Thanks are also due to Langdon Hammer for information on Hart Crane as well as to Karla Nielsen at the Columbia University Rare Book and Manuscript Library, for permission to use Crane's work sheets for *The Bridge;* to Mike Kelly, Head of Archives and Special Collections, and to Margaret Dakin, of Amherst College for help with the Emily Dickinson manuscripts; to James Maynard, Associate Curator of the William Carlos Williams Collection at SUNY Buffalo Libraries; to Melinda Watt and Eva Holiday DeAngelis-Glasser of the Antonio Ratti Textile Center at the Metropolitan Museum of Art; to Thomas Lannon and Kyle R. Triplett at The New York Public Library's Manuscripts and Archives and Rare Books Division for help with the Noah Webster papers; and to Diane Ducharme who made the transcription of the Webster fragment; and to Jason Burch for his help with the images in this book. And, finally, I owe deep thanks to Leslie Miller of The Grenfell Press.